COUNTRY SCENES
COLORING BOOK

DOT BARLOWE

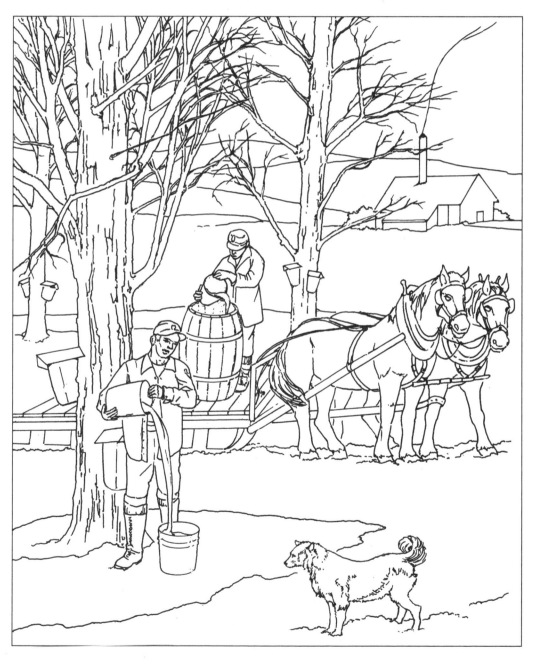

DOVER PUBLICATIONS, INC.
MINEOLA, NEW YORK

NOTE

Colorists, artists, and nature lovers of all ages will enjoy this collection of exquisite country scenes from gifted nature artist Dot Barlowe. Meticulously detailed representations of windmills, livestock, gardens, and fields, plus cheery scenes depicting the different aspects of life on the farm provide you with the perfect avenue for color exploration, and the unbacked, perforated pages allow for experimentation with the media of your choice.

Bibliographical Note

Country Scenes Coloring Book, first published by Dover Publications, Inc., in 2014 contains all the plates from *Country Scenes to Paint or Color* (2005), plus a selection of plates from *America the Beautiful to Paint or Color* (2006), *Nautical Scenes to Paint or Color* (2007), and *Birds to Paint or Color* (2007), all originally published by Dover.

International Standard Book Number

ISBN-13: 978-0-486-49455-5
ISBN-10: 0-486-49455-1

Manufactured in the United States by RR Donnelley
49455110 2015
www.doverpublications.com

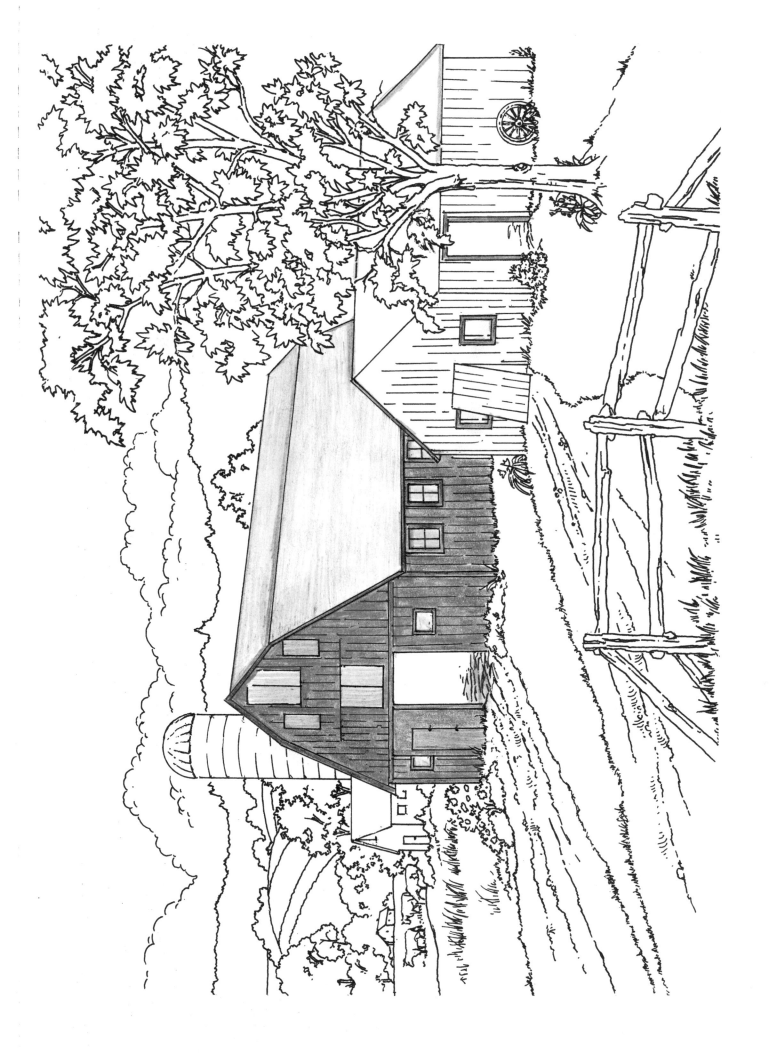

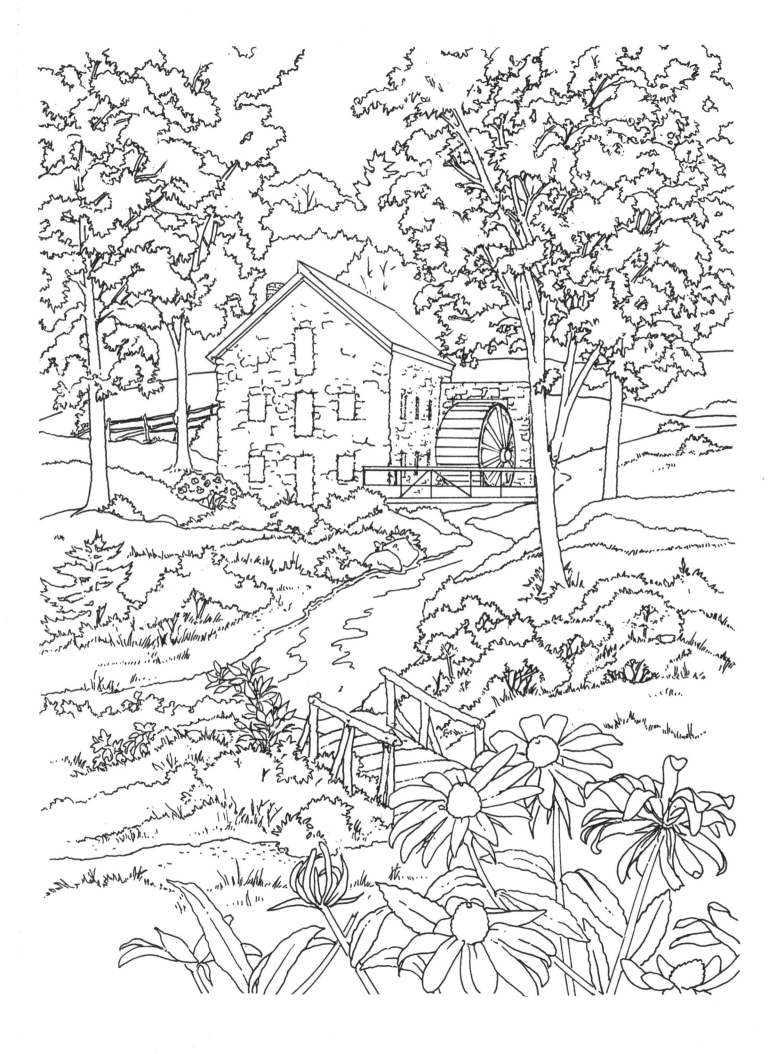

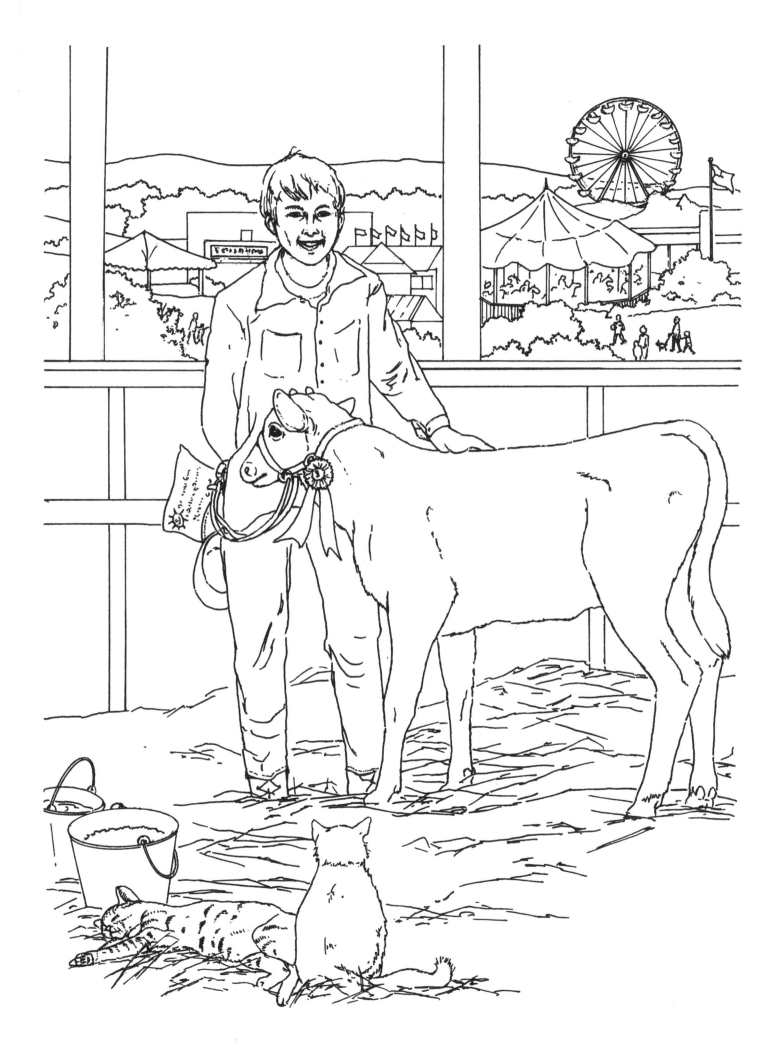

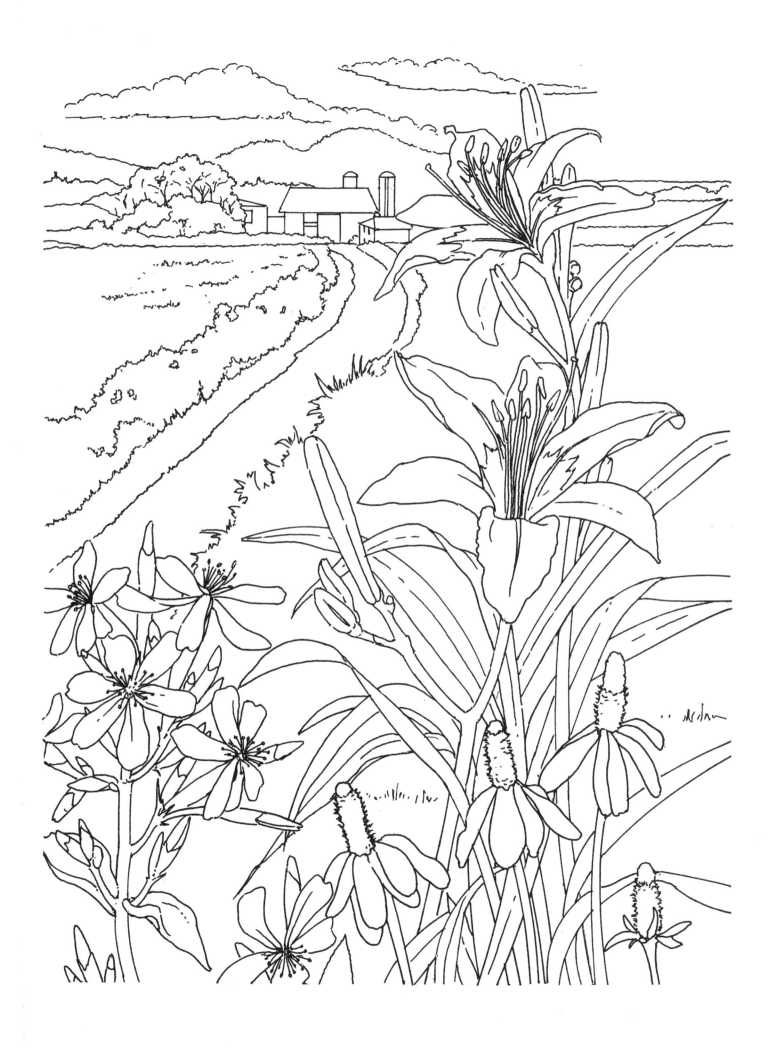

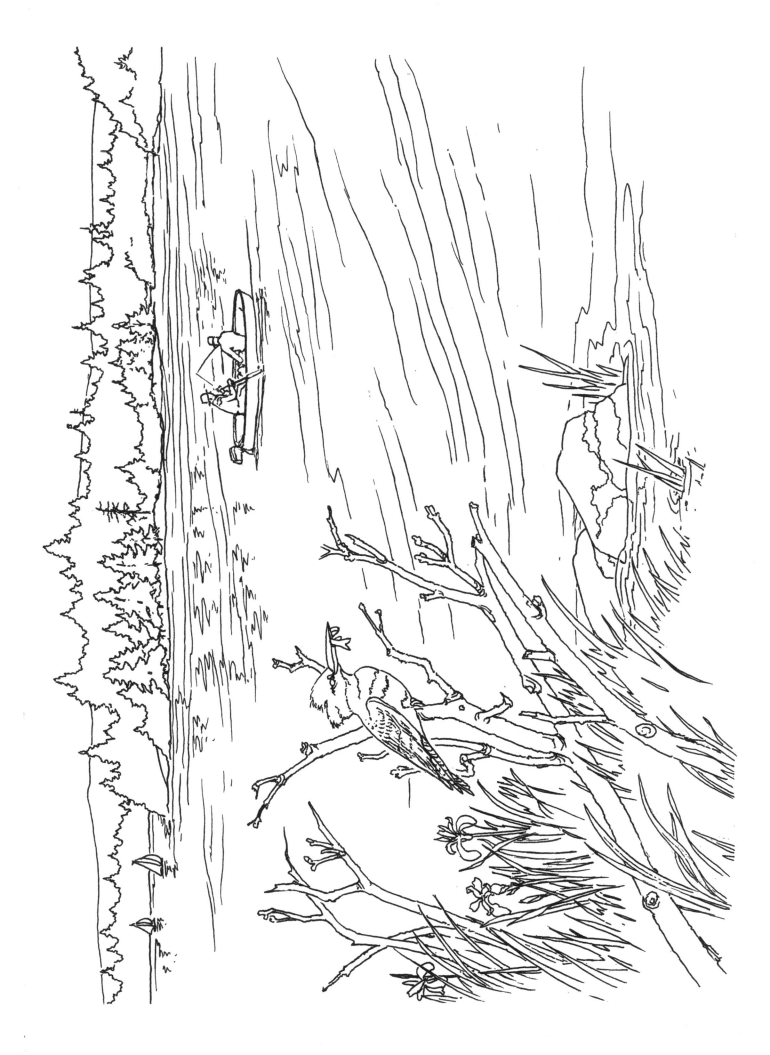

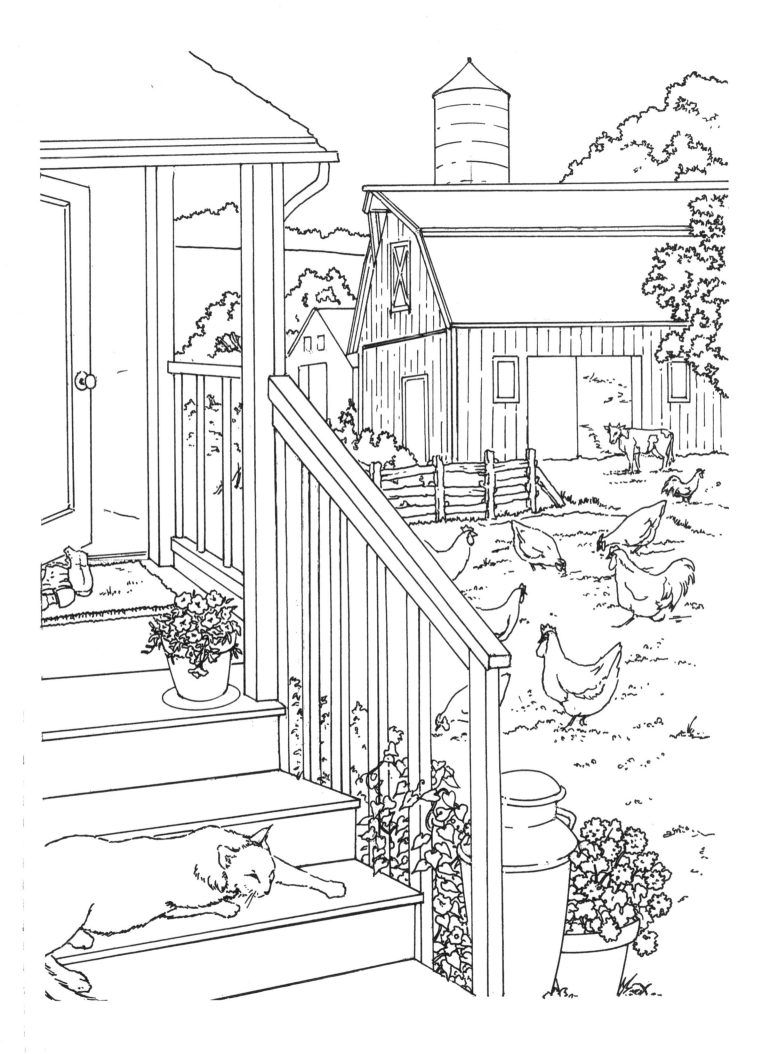

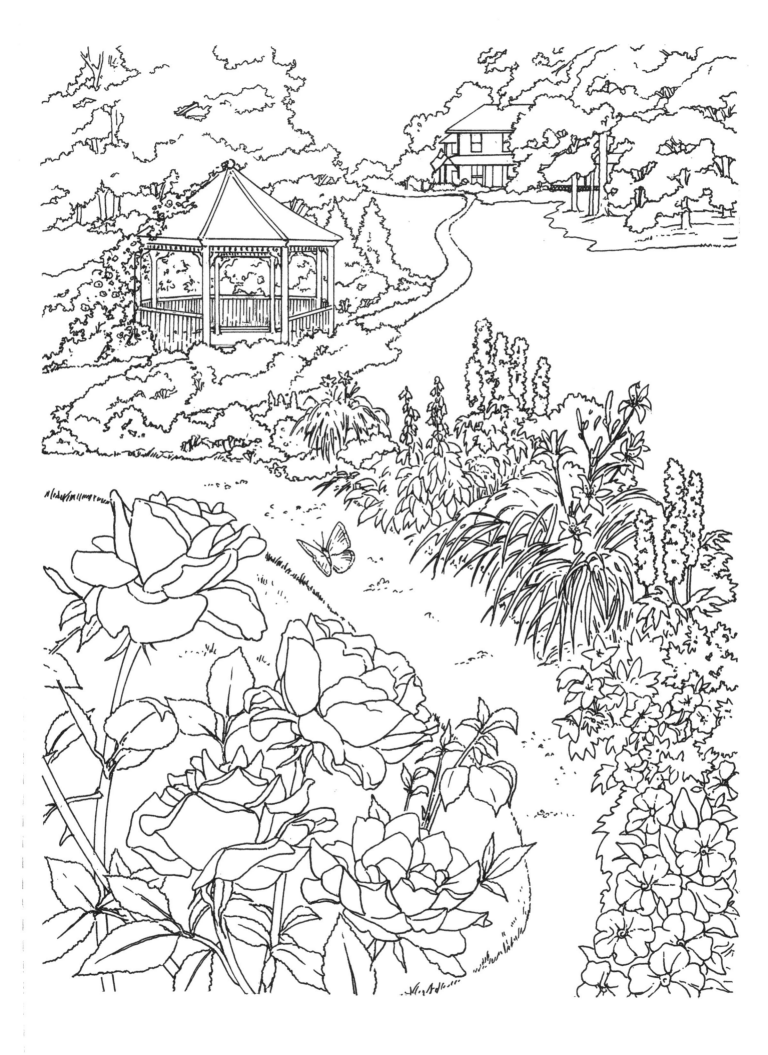

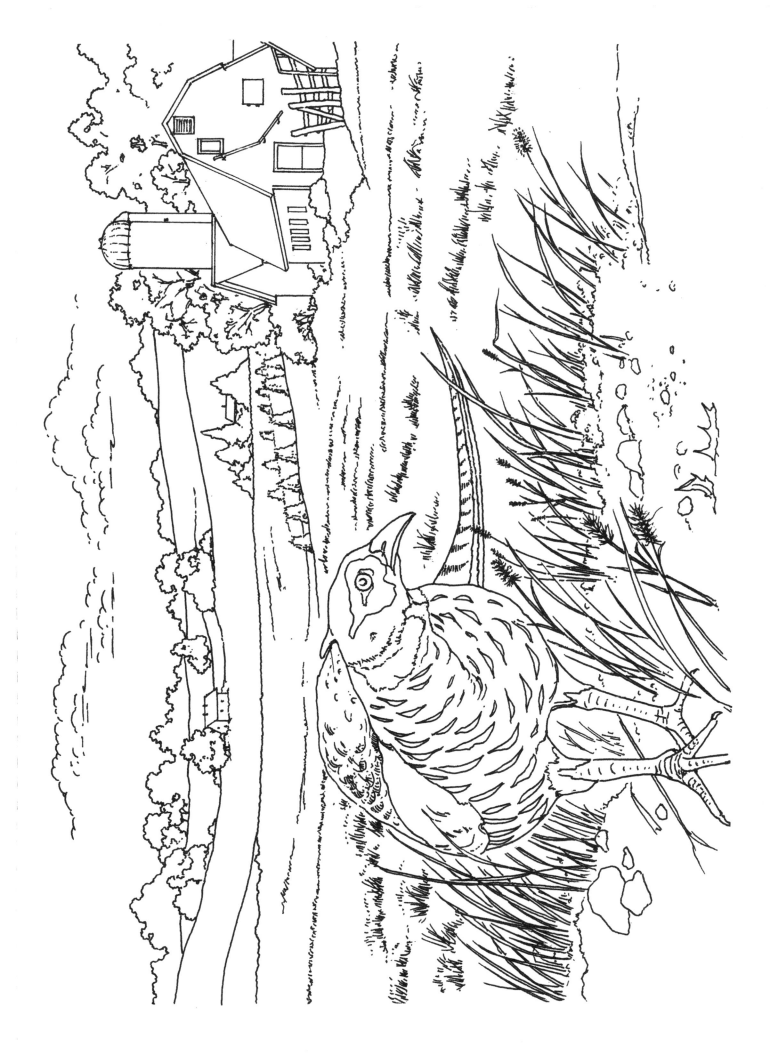

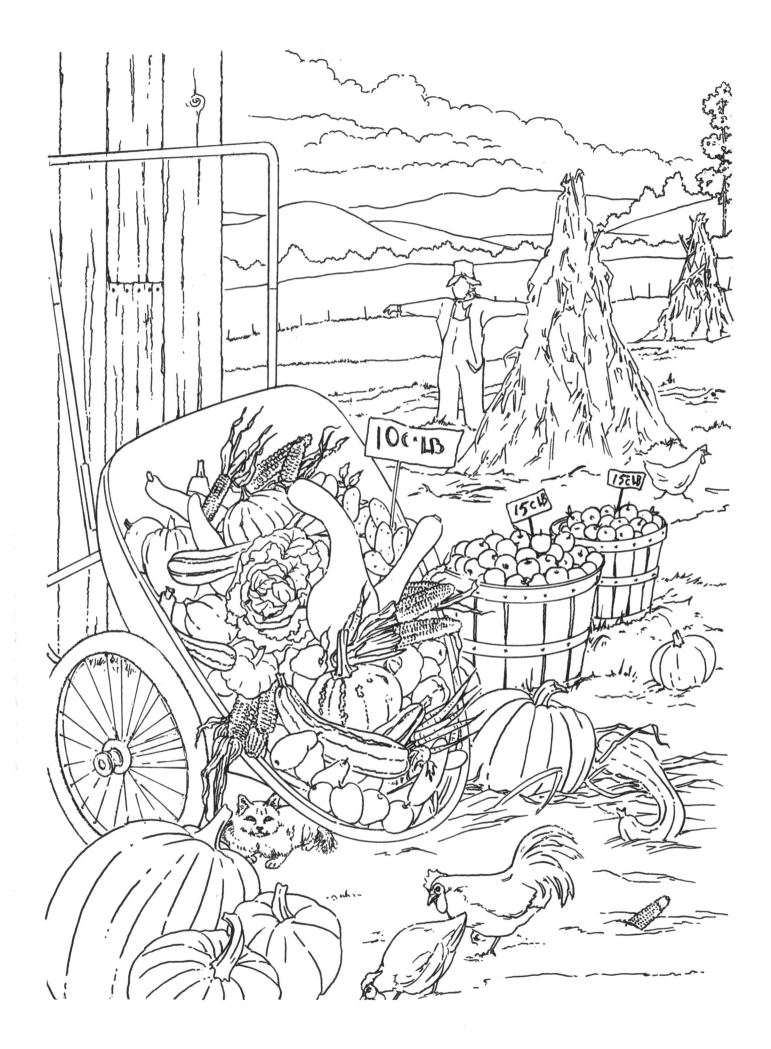

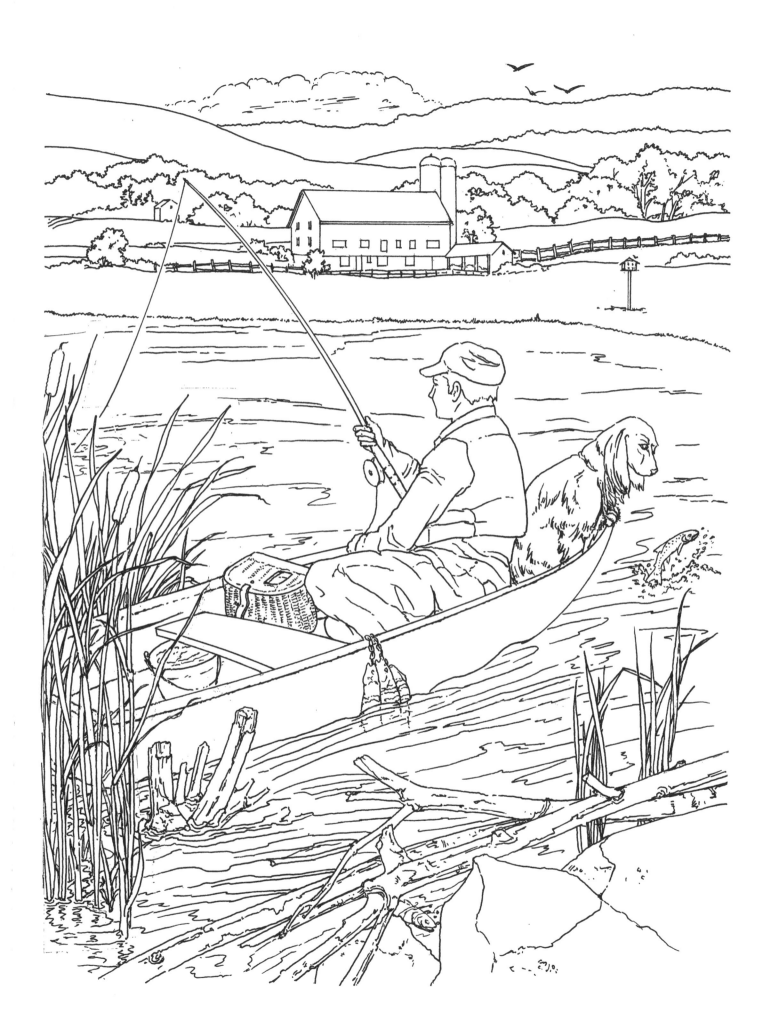

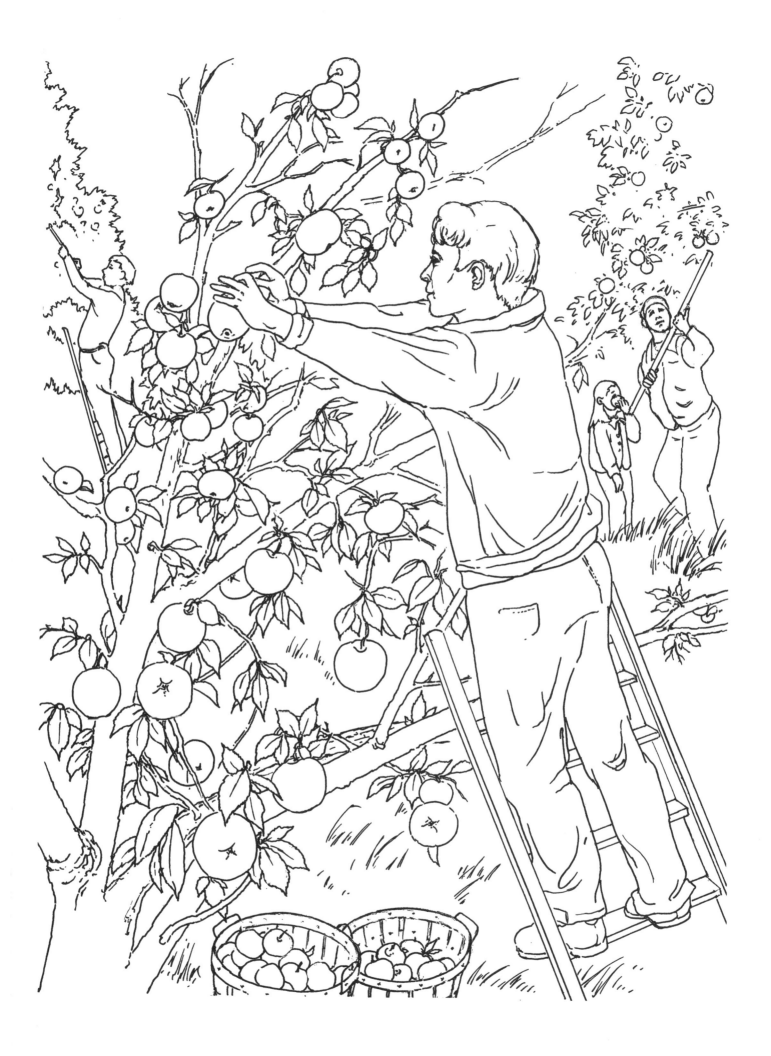

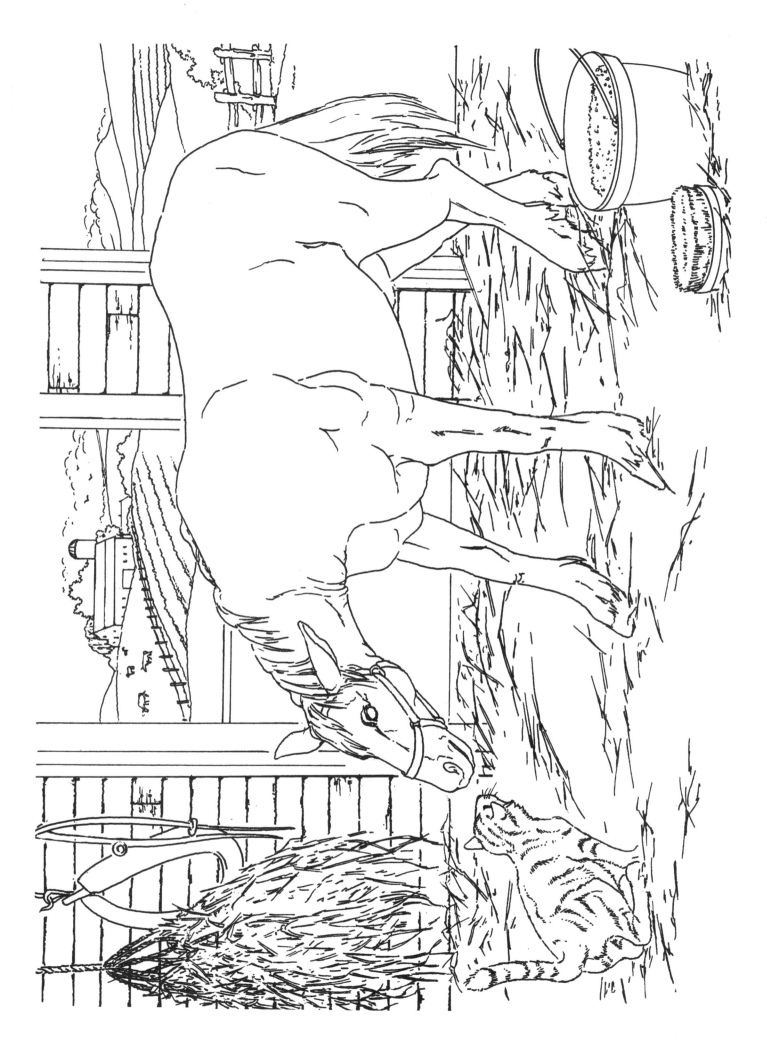

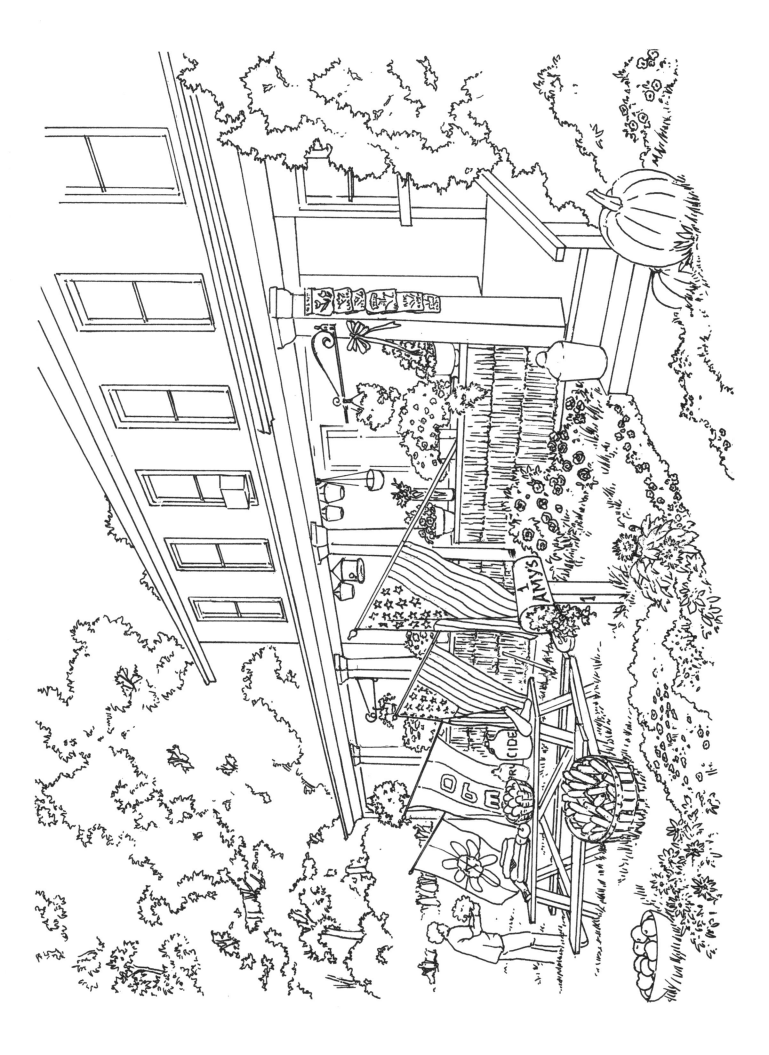

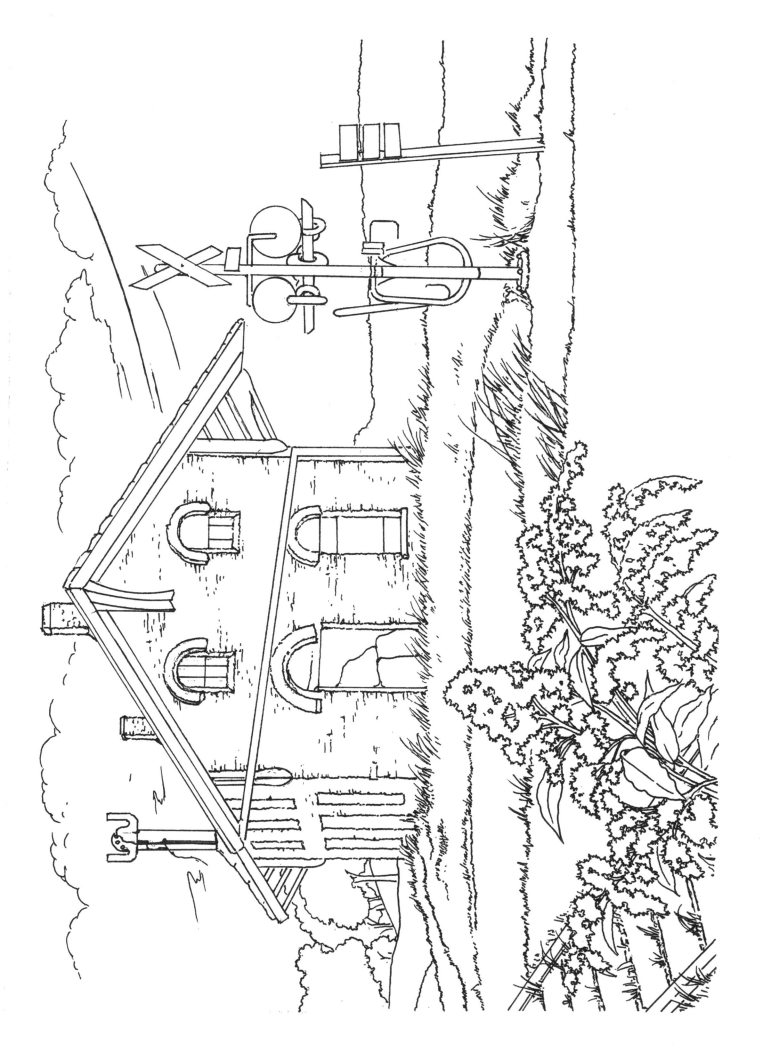

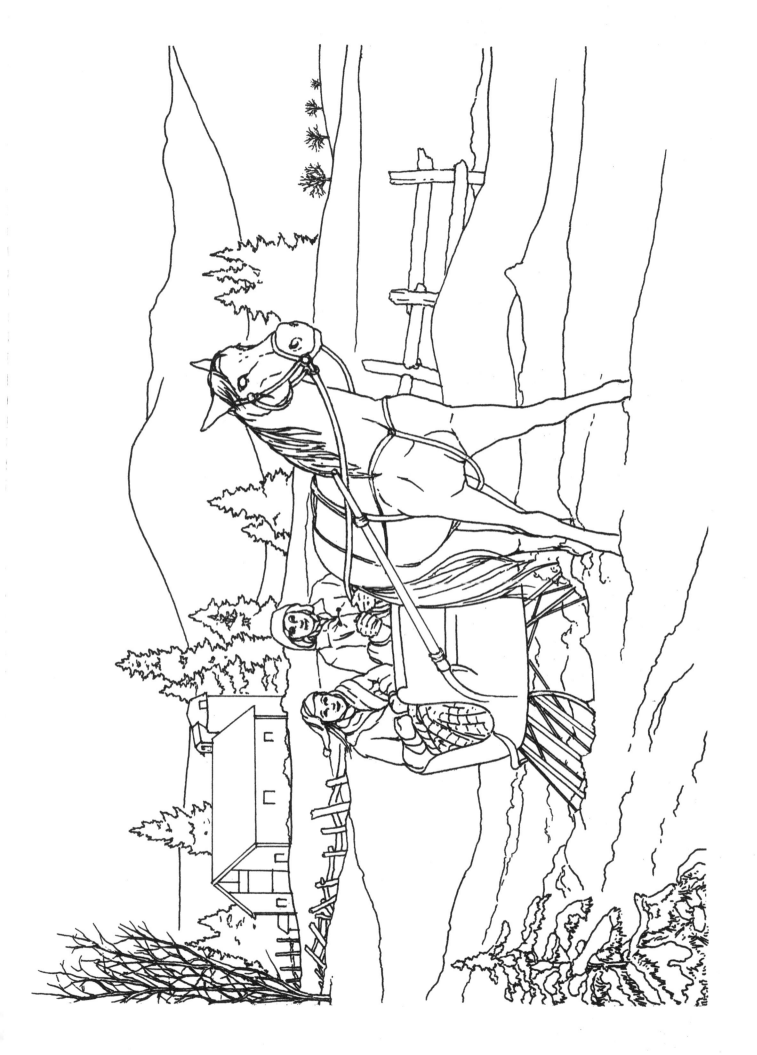

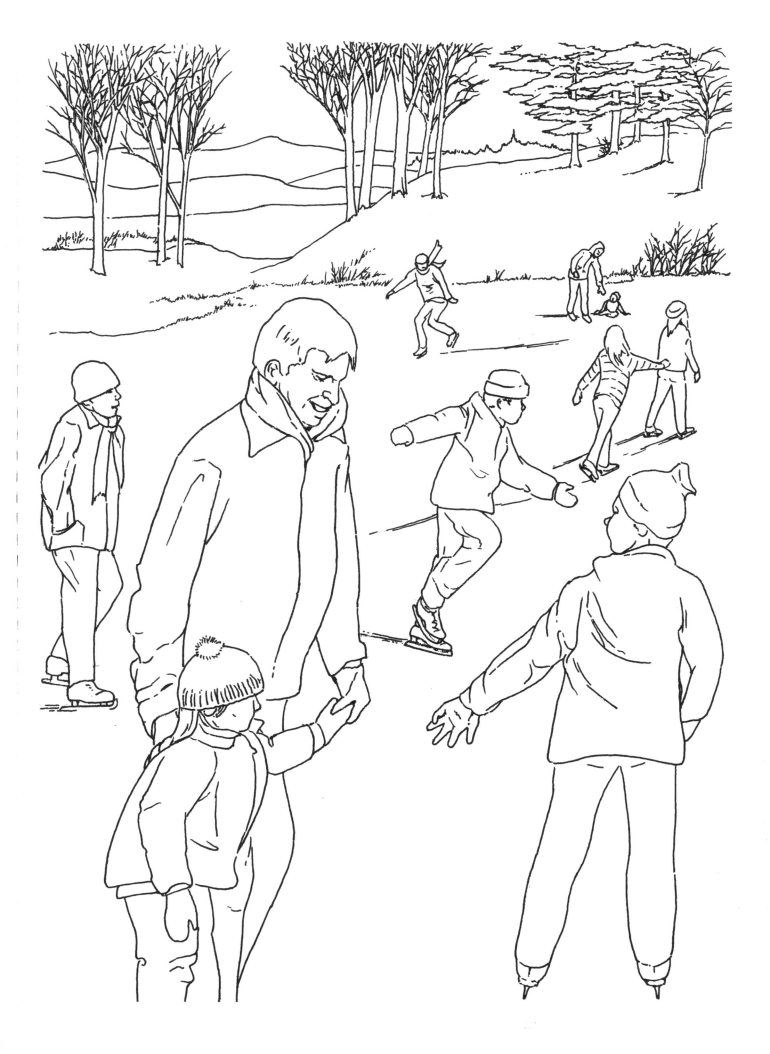

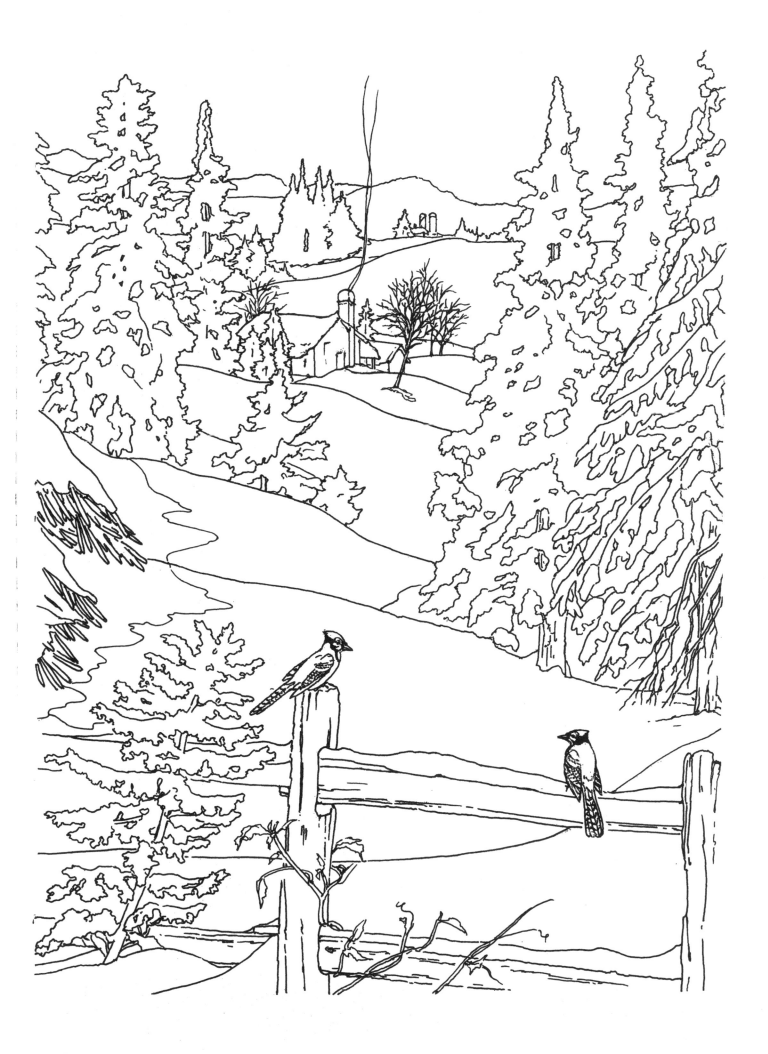

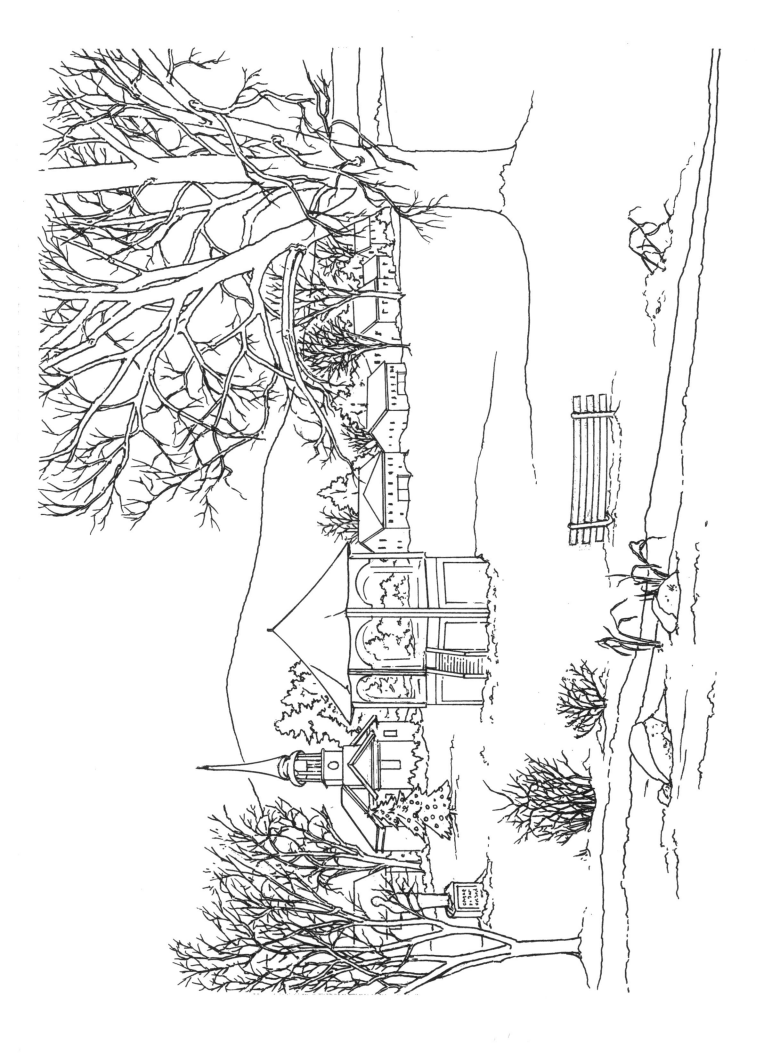

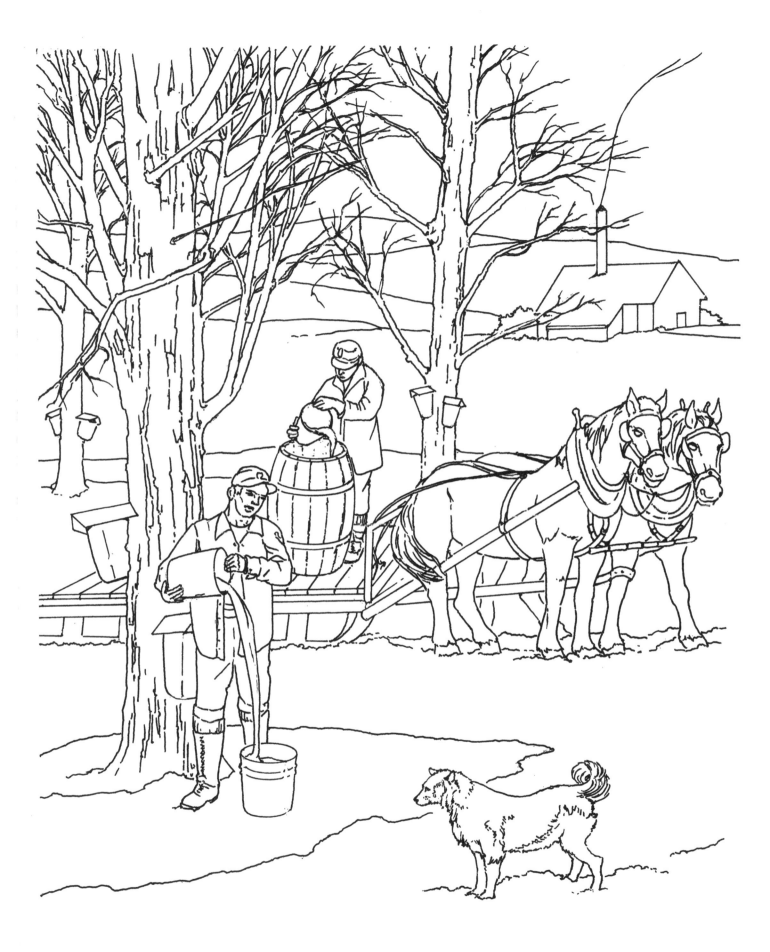

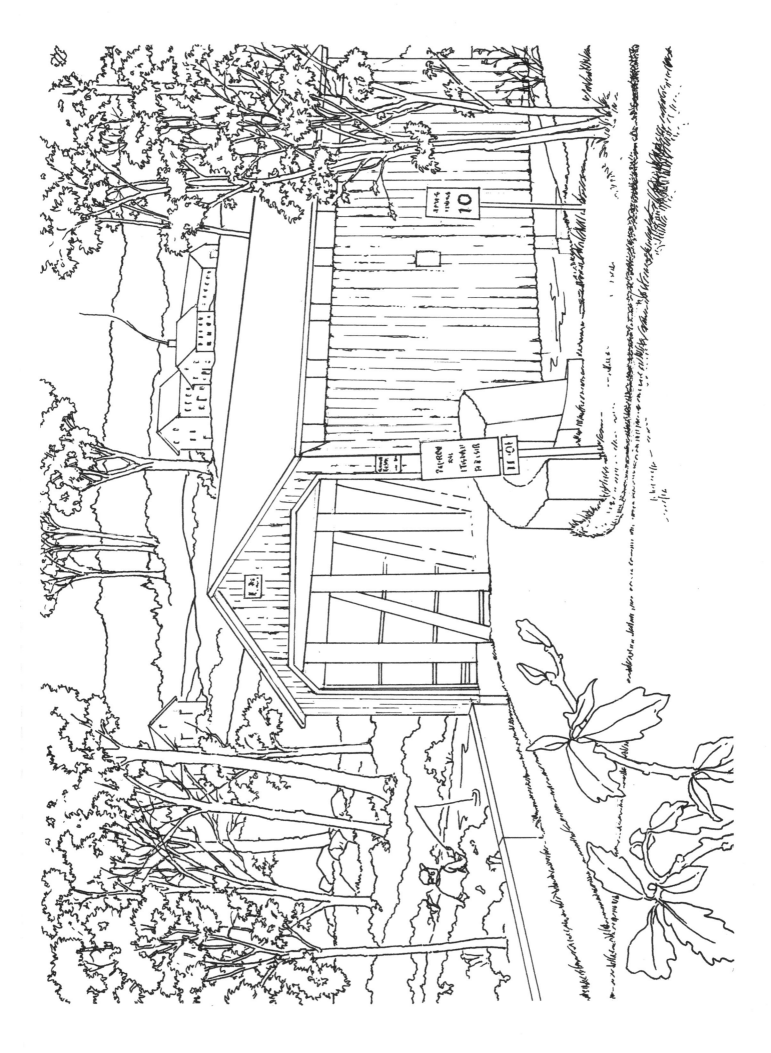

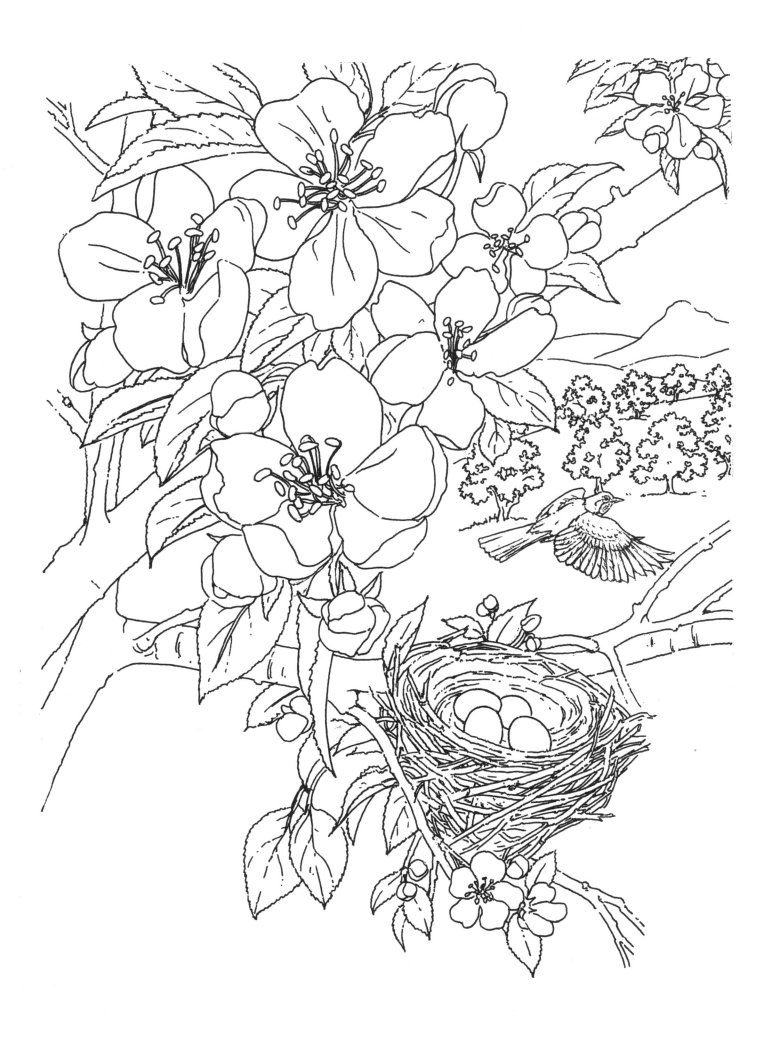

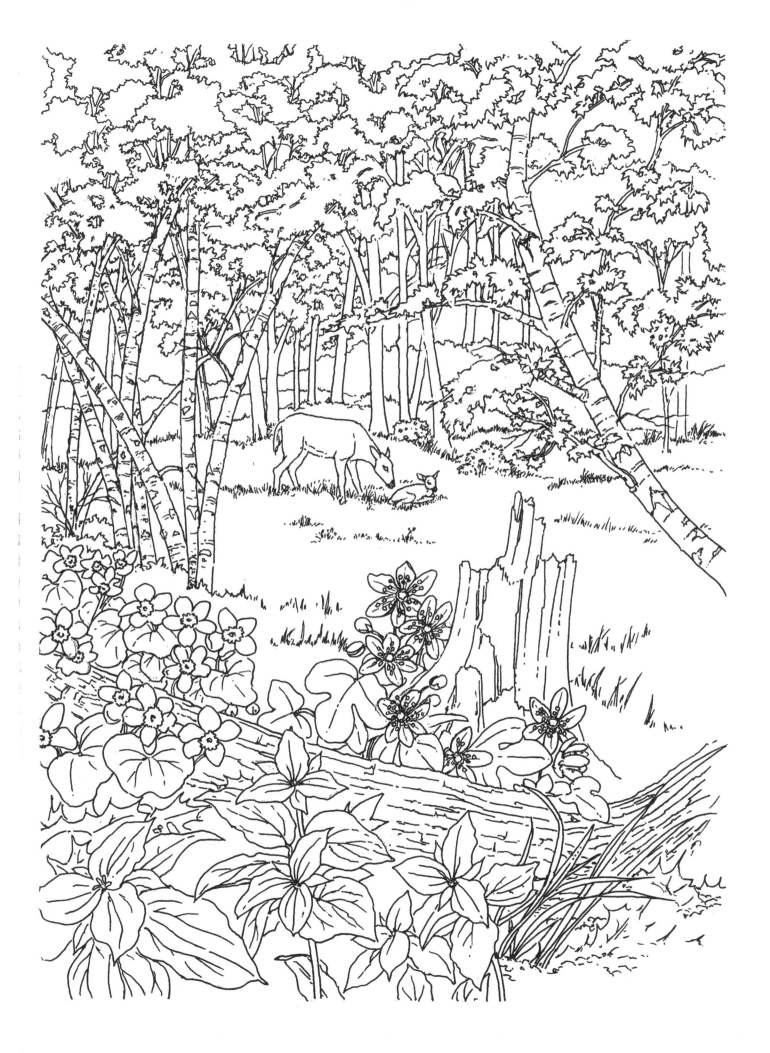

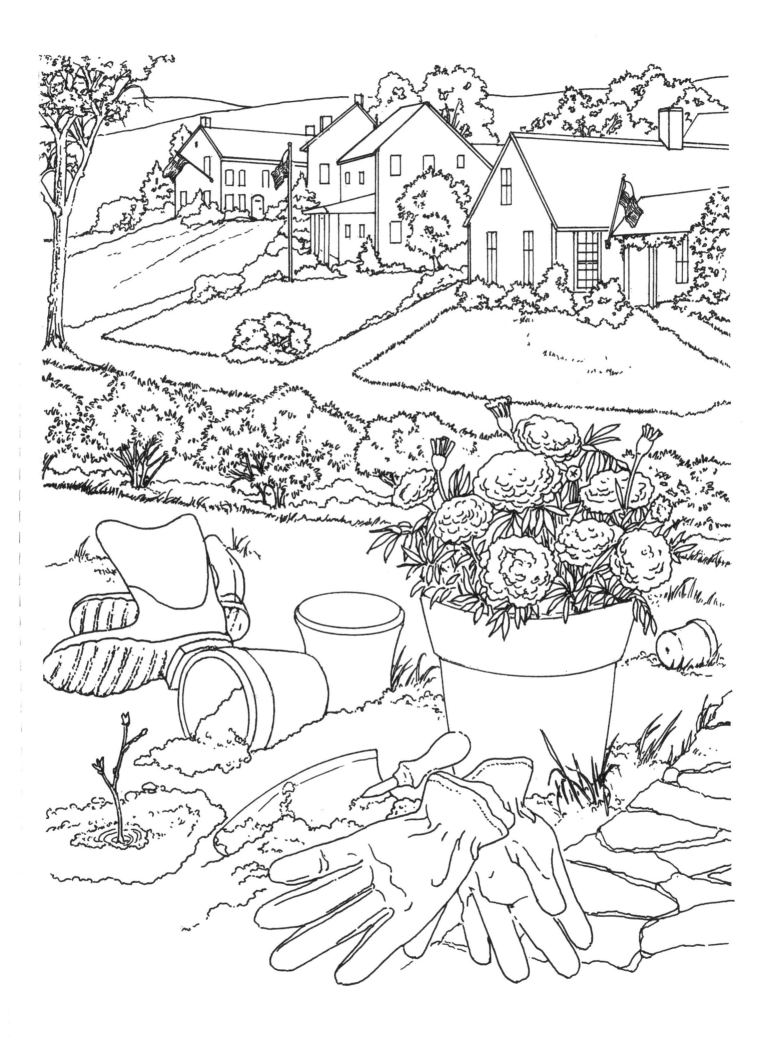

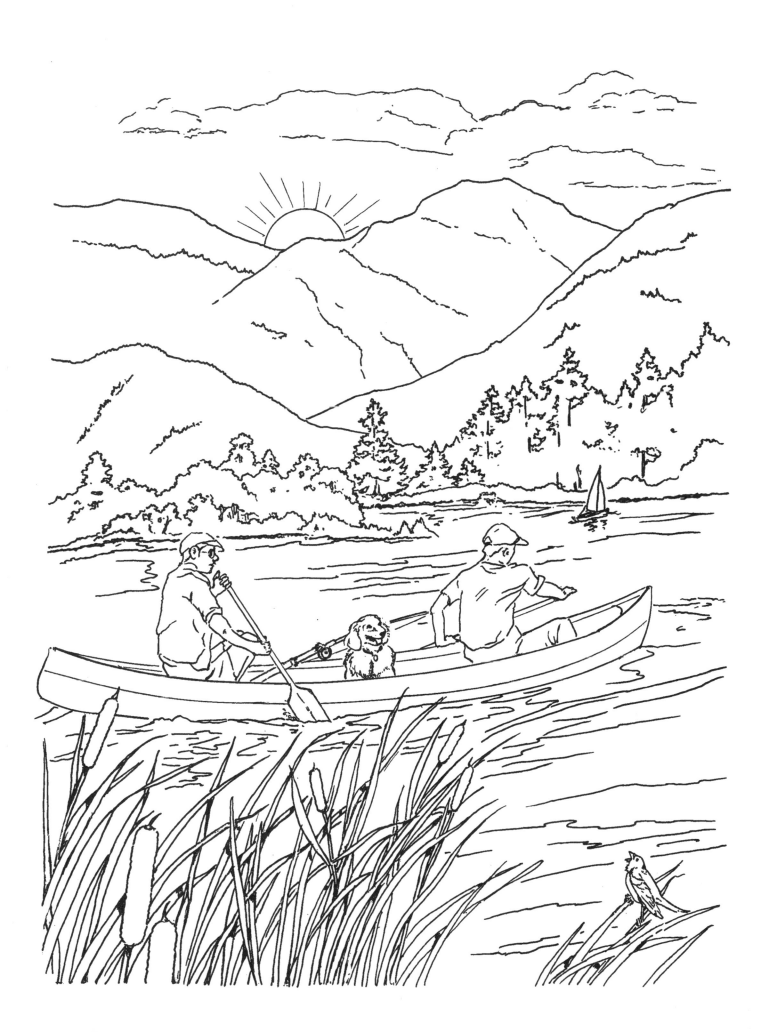

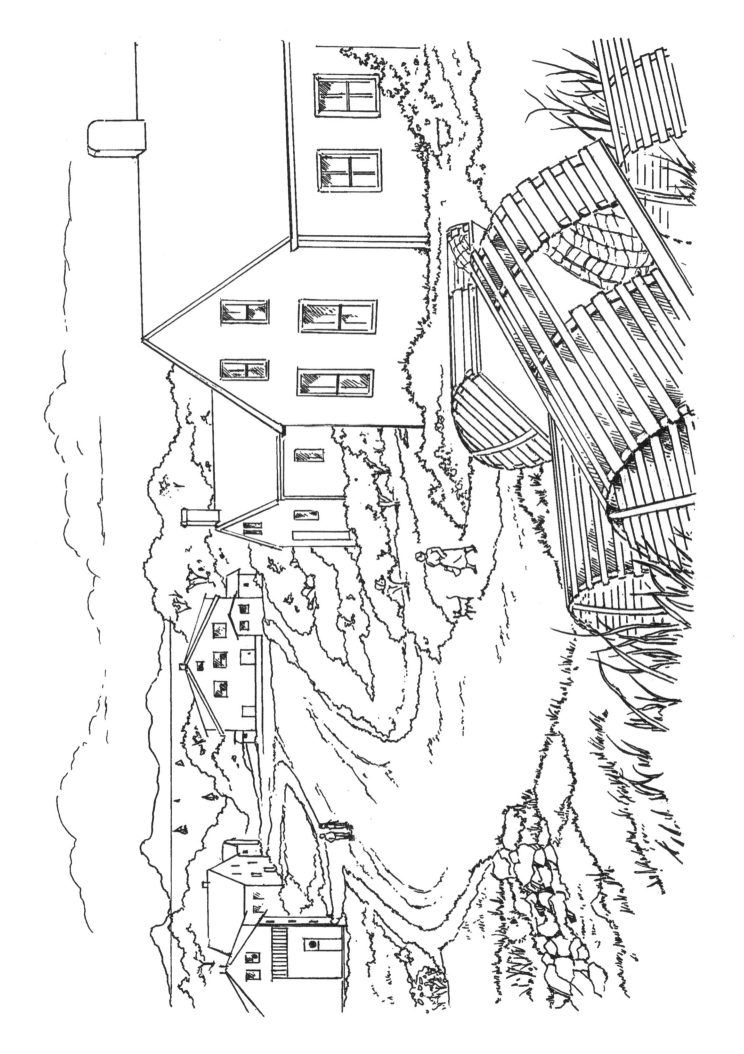

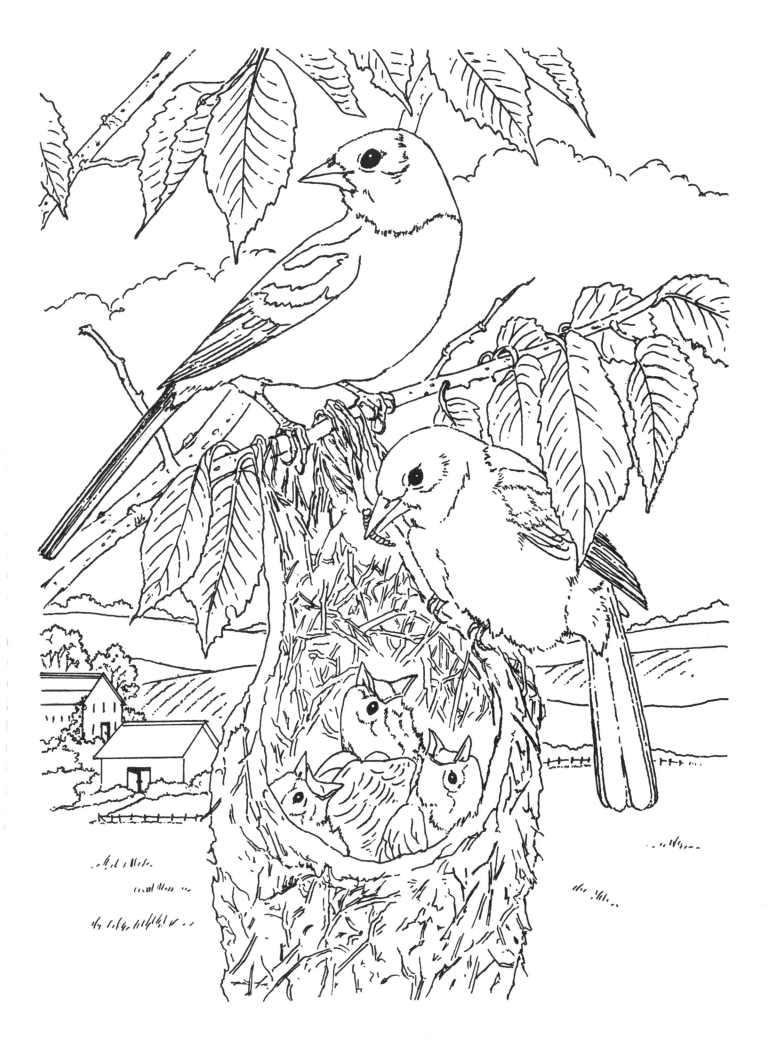

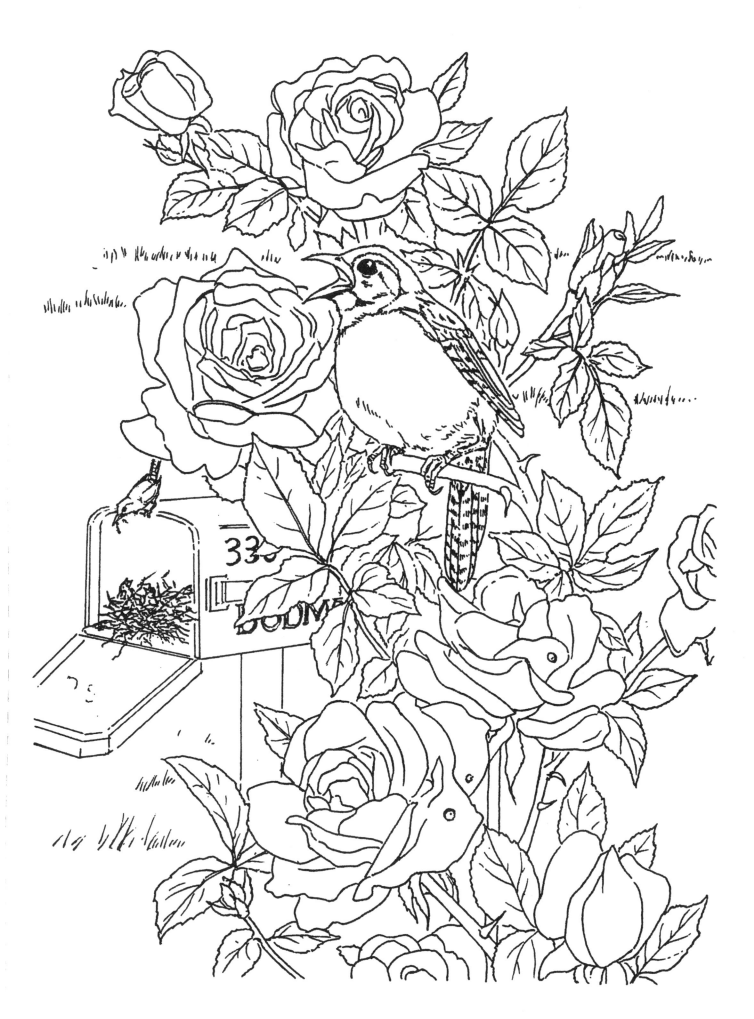